MOODLES

··· presents ···

Stressed

This edition published by Parragon Books Ltd in 2015
and distributed by

Parragon Inc.
440 Park Avenue South, 13th Floor
New York, NY 10016
www.parragon.com

Written and illustrated by Emily Portnoi
Edited by Frances Prior-Reeves

ISBN 978-1-4748-0431-8

Printed in China

MOODLES

··· presents ···

Stressed

PaRRagon

Bath • New York • Cologne • Melbourne • Delhi
Hong Kong • Shenzhen • Singapore • Amsterdam

Welcome
to your moodle book.

"What is a moodle?" I hear you ask.
Well, a moodle is just a doodle with
the power to change your mood.
Be it stressed to blessed, sad to glad,
or blessed back to stressed. Cheaper
than therapy, quicker than chanting
chakras, tastier than a cabbage
leaf and sandpaper detox, and less
fattening than chocolate cake!

The moodle: a simple thing that can really turn your day around.

All you need is a pen or pencil, imagination, and an open mind. Be prepared to delve into your innermost thoughts, ideas, and concepts. Uncover your subconscious and lay it bare on the page — admire it, mock it, and marvel at it until you feel altogether more relaxed. Let the moodle wisdom penetrate your subconscious and guide you on a magical mental journey. Follow the mark you make, until it's the end of the line for your stress!

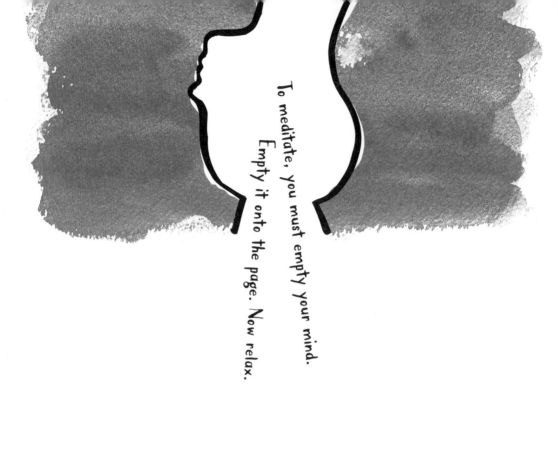

To meditate, you must empty your mind. Empty it onto the page. Now relax.

Don't stress the *little things.*

Draw five things that are smaller than your thumbnail; then disregard them.

Fill your head entirely with **calm thoughts** and moodles.

Make sure there's no room at all for worries or stress to creep in.

Moodle out all your
worries onto this
airplane.

Cut out, fold, and then
send it flying — watch
your troubles
disappear into the
distance.

How to make your *airplane*:

1

2

3

4

5

6

7

Take leave of your senses.
Moodle with your eyes closed.

THAT 400-PIECE PUZZLE STRESSING YOU OUT?

Well, with THIS puzzle, all you have to do is draw the finished picture. And the best part? No losing a small piece of blue sky.

Exercise can **really** calm your mind.
Take this book for a short, fast walk;
then chart your journey on this page.

Draw a picture entirely in calming shades of **blue**.

Focus on the **big** picture.

Complete this drawing.

According to Zen philosophy, the key to inner peace is to **consider things from every angle.** Pick an object and moodle it from nine different angles.

Show your stress the door.

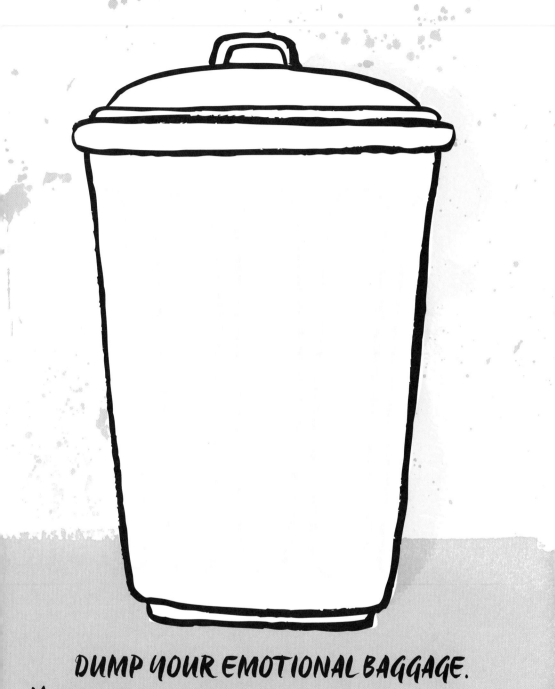

DUMP YOUR EMOTIONAL BAGGAGE.
Moodle all your negative history into this garbage can.

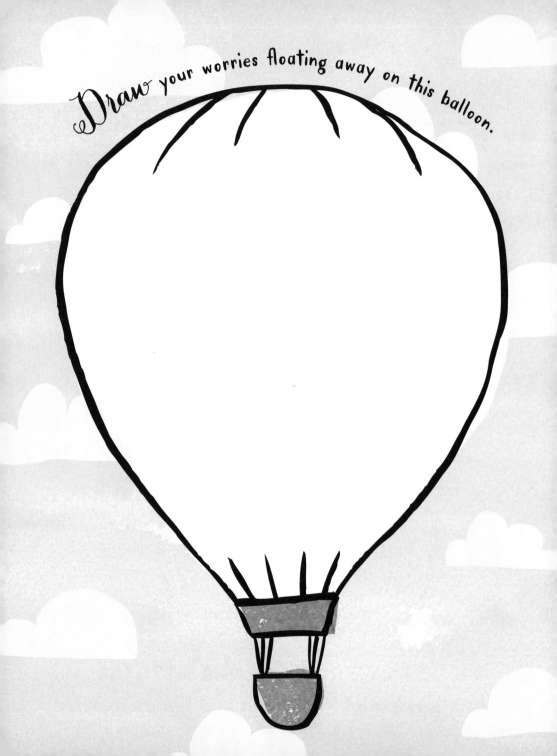

Draw your worries floating away on this balloon.

Moodle Zen Master says:
stop procrastinating. Just draw something!

You've got 15 seconds from now.

Slow down!

Try moodling at half the speed you normally would.

Learn to love yourself. Moodle five things that are **great** about you.

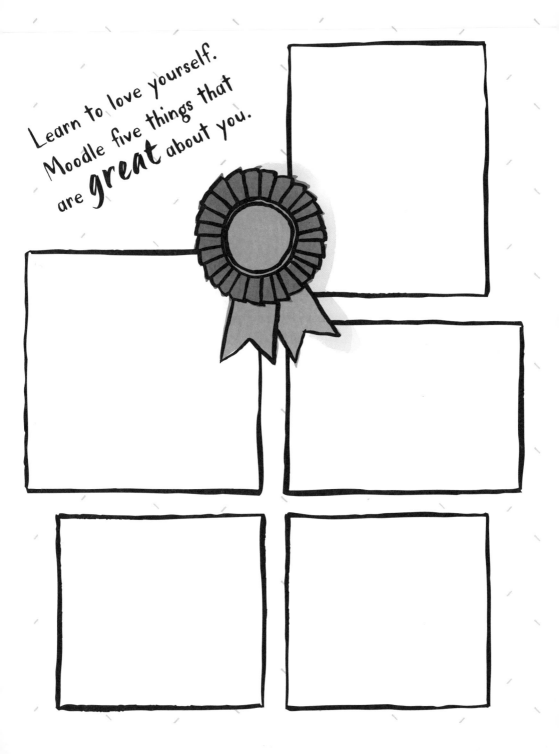

Hooray! This gallant soldier will fight for your honor!
Draw your stress taking a mighty beating.

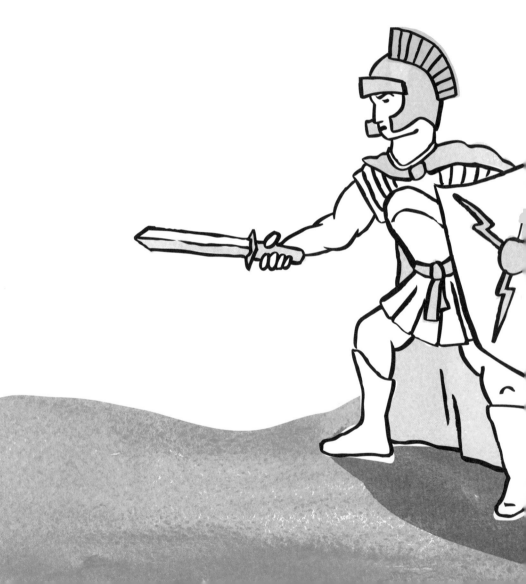

Giving is great for you!

Draw a picture, tear it out, and give it to someone.

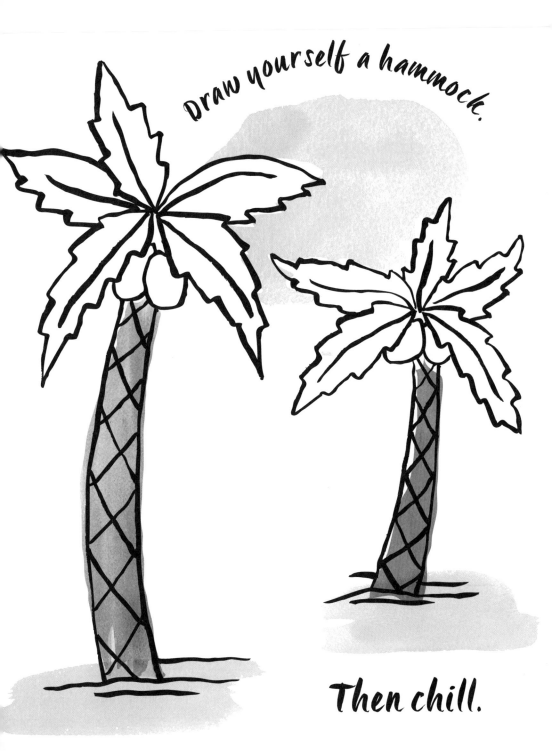

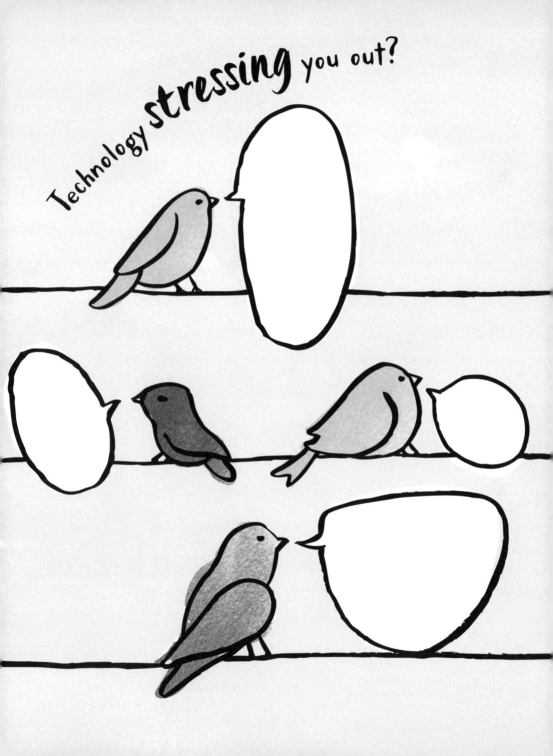

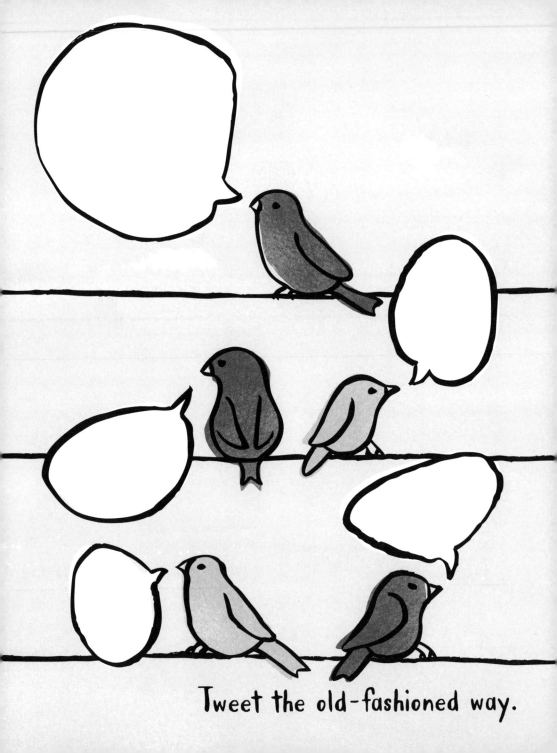

Tweet the old-fashioned way.

Write a break-up letter to your stress.

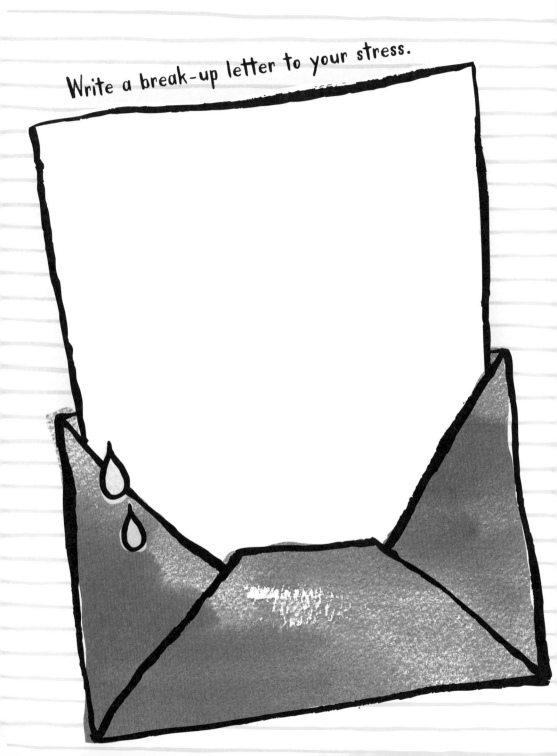

Moodle *outside the box*.

Draw four people who **REALLY BOTHER YOU.**

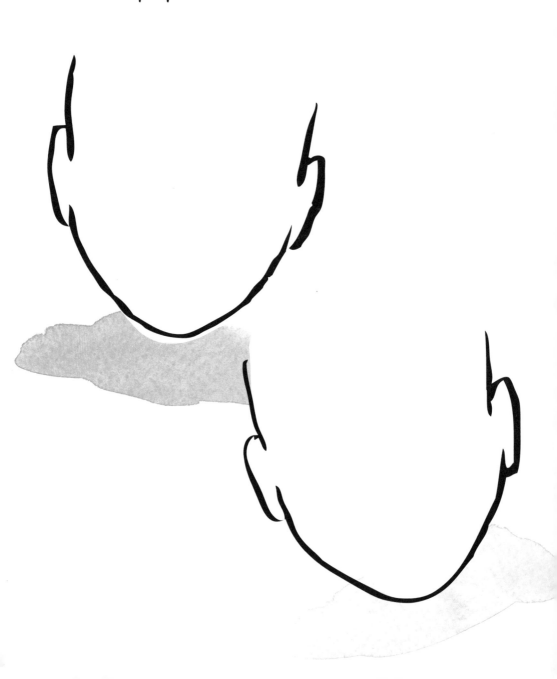

Then close the book and walk away.
Get some distance.

Moodle a bear to hug.

Then hug it out.

Repeatedly write the line "My stress will disappear," over and over on this page, until it is no longer legible.

Lock up your inner doubts

so that they can't hold you back.

Dance your worries away.

Moodle the top half of yourself here.
Cut out the two circles, pop your fingers through;
then bop till you drop!

Oh no! Here comes your evil stress monster.

Moodle it some wings and watch it fly away.

Draw ten things you're worried about. Then scribble out 8.5 of them, because **85% of the things you worry about never happen.**

That leaves you freer
to worry about the
remaining 15%.

Moodle the waterway that this leaf is floating on. Where is the leaf going?

Short on time? Here's an extra week
— fill it however you like.

MONDAY

TUESDAY

WEDNESDAY

THURSDAY

FRIDAY

SATURDAY

SUNDAY

Frederick the donkey lacks purpose and direction.
Load him up and set him on a path.

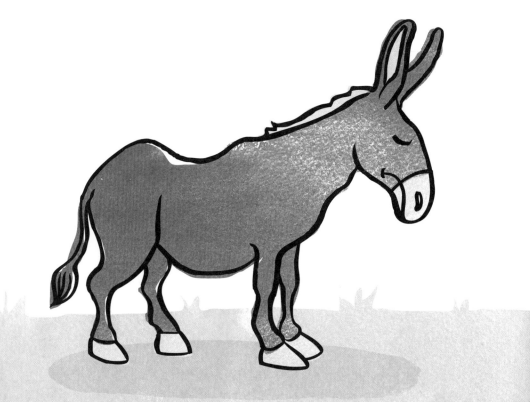

According to those in the know
having a pet seriously reduces stress.

So draw your own fluffy friend and stroke your worries away.

You need a change of scene. Moodle your ideal view.

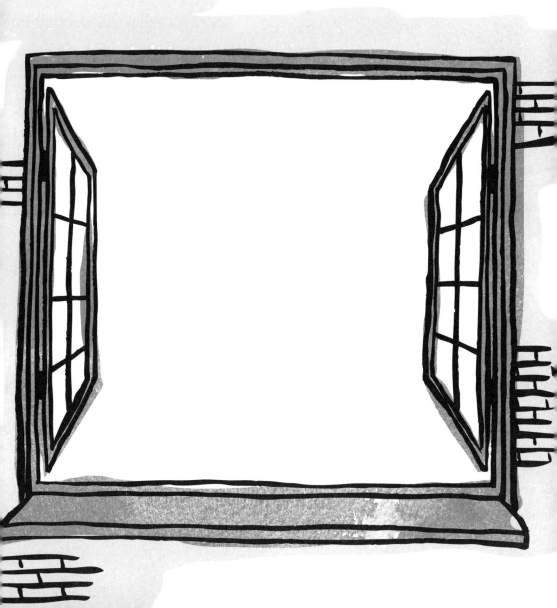

It's important to achieve balance in your life.

Draw a symmetrical moodle.

Draw your **STRESS HEAD**;
then squash it in the pages of this book.

Focus your mind. Keep drawing circles until you achieve the perfect sphere – and true enlightenment.

Take some time for you.
Turn this page into a Do Not Disturb sign.

Moodle your way out of your stress maze.

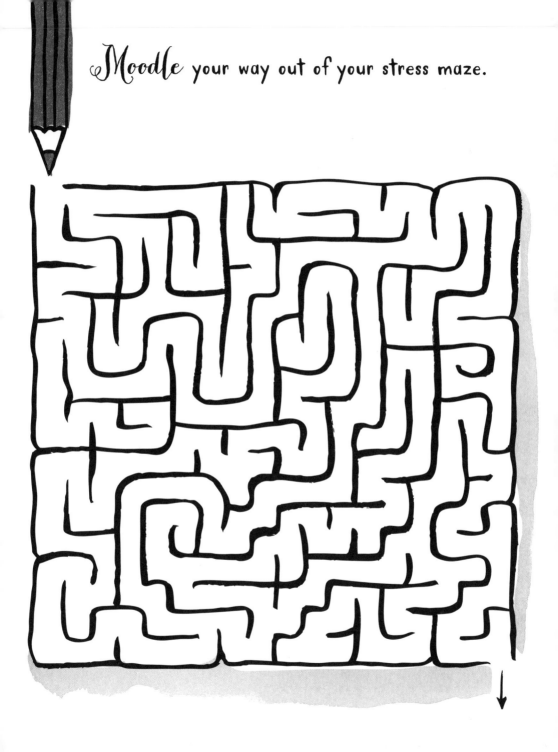

It's important not to **compare** yourself.
Draw a little ship on Wednesday for the next four weeks.

Notice the merits of each drawing, but don't compare.

Loosen up!

Close your eyes (not yet, finish reading first!) shake your arms, shake your hands, shake your head, take a deep breath. Then, moodle the first thing that comes into your mind.

Take two different colors, and make them fight on this page.

Who won?

Or did they just agree to disagree, or did they blend into one?

Moodle meditation.

Draw the first thing you think of when you read...

Weightless

Distance

Glow

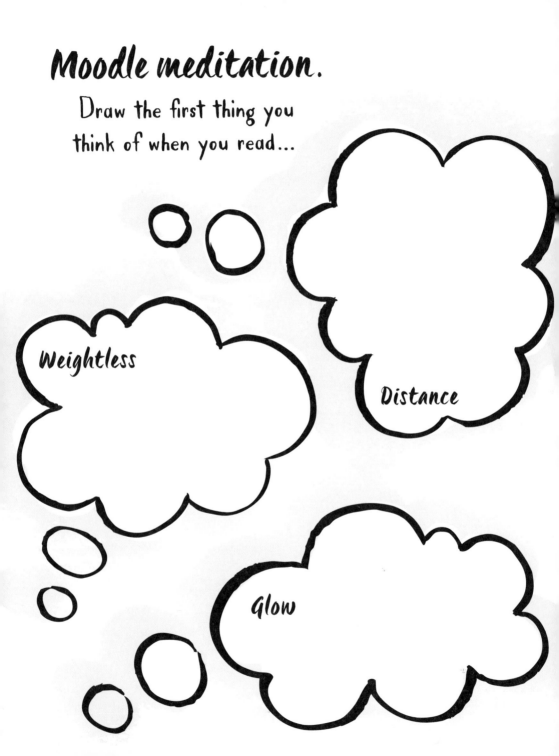

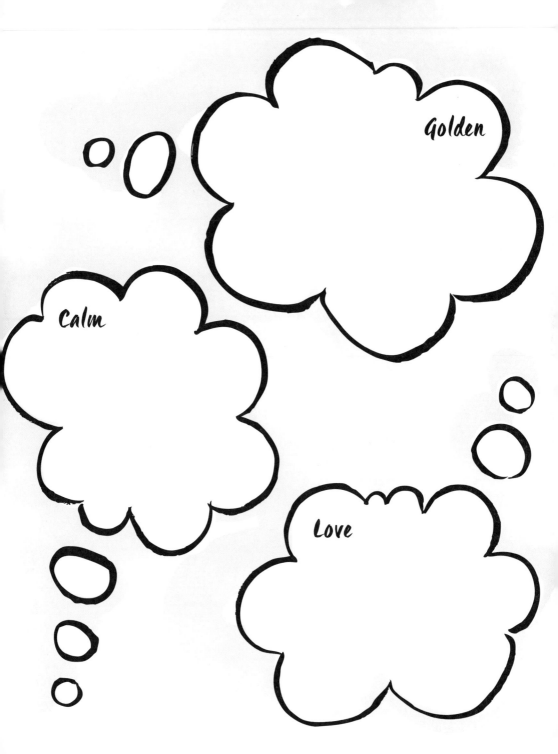

Connect the dots in any order you
like — there is no right or wrong
answer and no pressure.

Keep going until you have your
own wonderful, unique design.

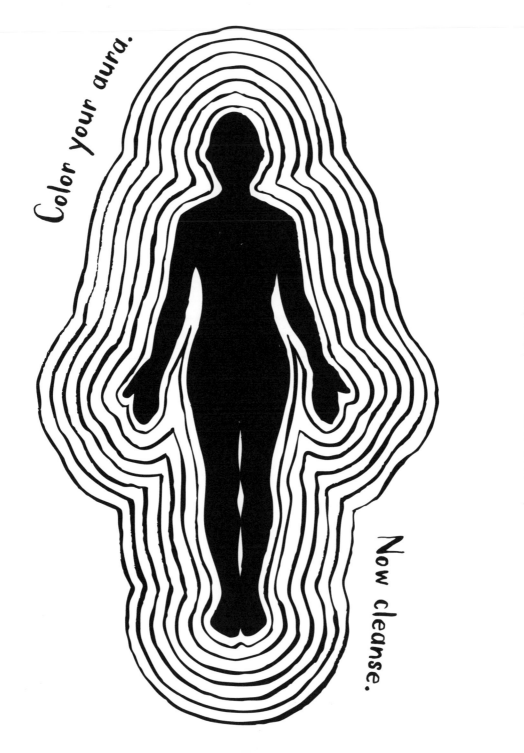

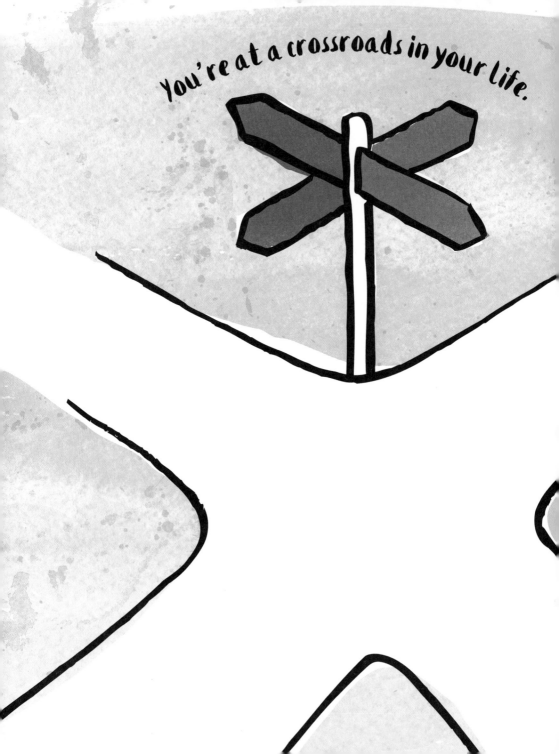

Draw what's on the various
paths you could go down.

Moodle the you you'd like to be.

Explore your senses.

Draw what you can taste, smell, and hear.

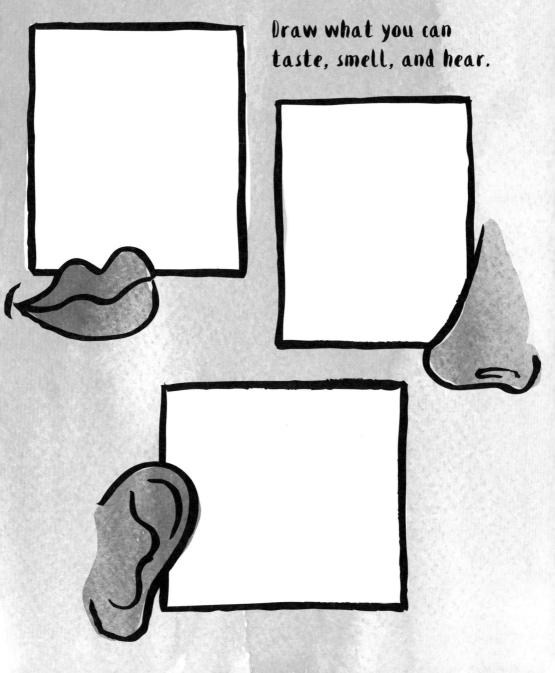

Create a calming atmosphere.

Moodle some flickering candles giving off a warm glow.

Ahoy there!

Moodle all of your
stress onto this jolly
little boat; then let
it sail away.

BON VOYAGE!

How to make your *little sailing boat:*

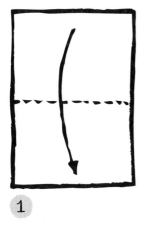

1

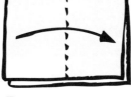

2

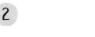

3

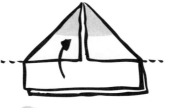

4

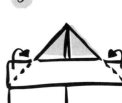

5

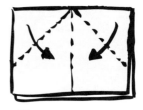

6

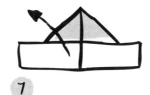

7

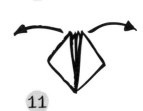

8

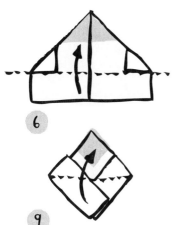

9

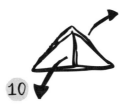

10

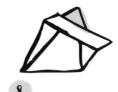

11

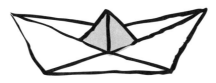

to see creatures emerging and then draw in their missing features.

WANTED

★

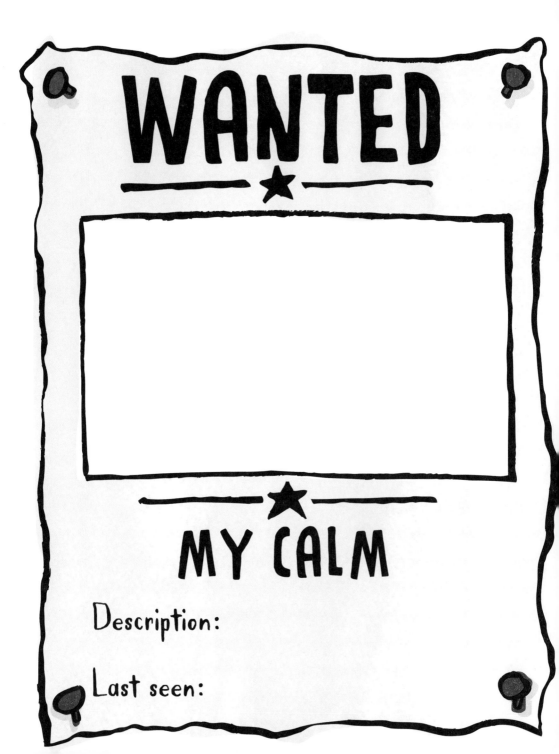

★

MY CALM

Description:

Last seen:

Elude your stress.

Moodle your own cut-out-and-keep disguise, so it can't recognize you.

Sometimes you have to realize you can't control everything and just accept that some things are out of your hands.

So why not try moodling with your toes?

Life's a roller-coaster ride.

Moodle yours.

Make yourself feel like *a new person.*

Moodle yourself a fresh wardrobe.

Learn to say "No!"

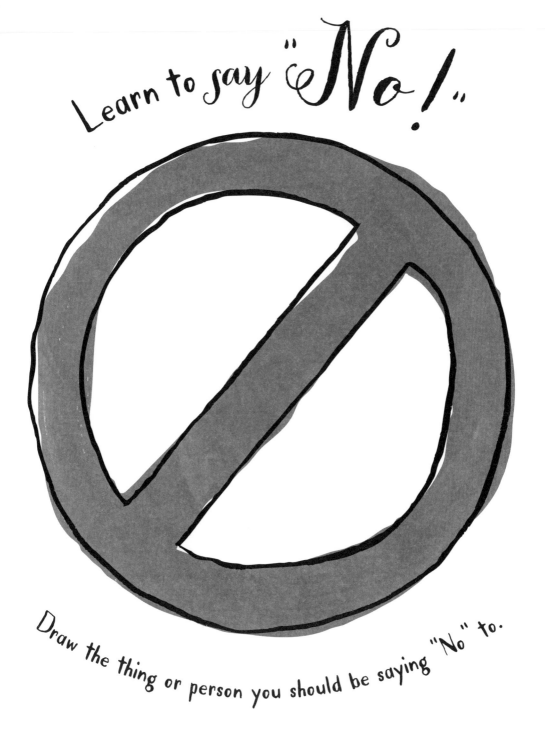

Draw the thing or person you should be saying "No" to.

Taking ten deep breaths is a great way to calm yourself down, BUT moodling to ten is even better.

Did you know **kissing** releases chemicals that ease hormones associated with stress?

So practice your pucker here.

Moodle a *beautiful location* in nature;
where calmness reigns supreme and stress is banished.

It's tough trying to stay on top of everything,

but it's easy with a moodle. Moodle yourself on top of a huge pile that represents your life. Plant a flag while you're up there!

Escape from your stress into a good book.

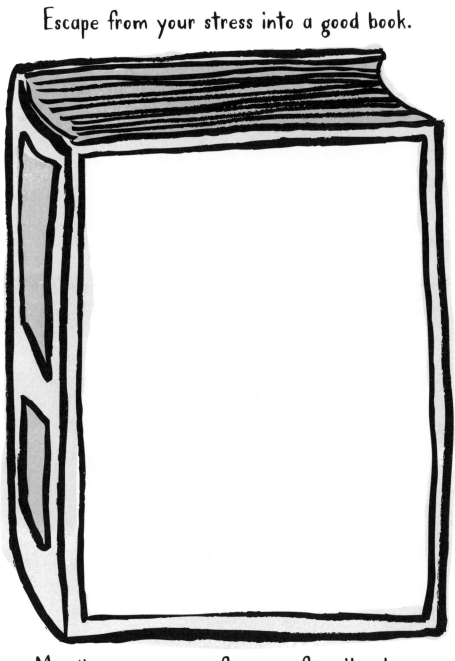

Moodle a new cover for your favorite story.

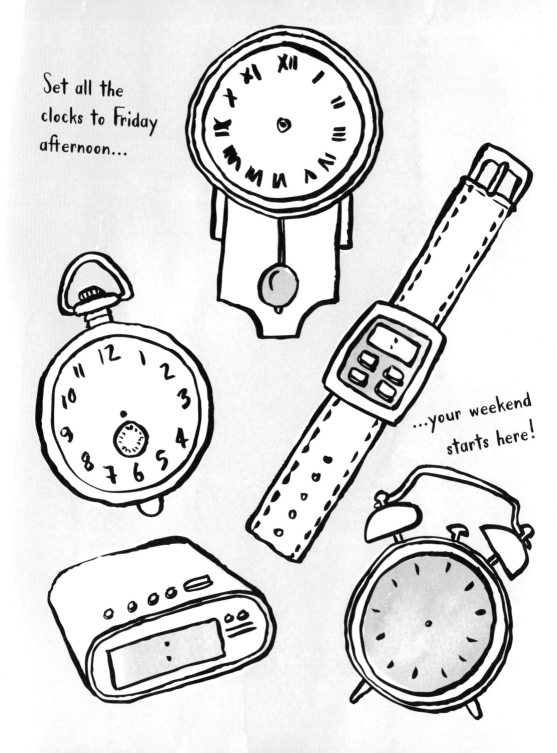

Set all the clocks to Friday afternoon...

...your weekend starts here!

The pursuit of perfection

can be stressful. This page is reserved
especially for mistakes and bad moodles.

Stay positive.
Draw **three** things that make your life awesome.

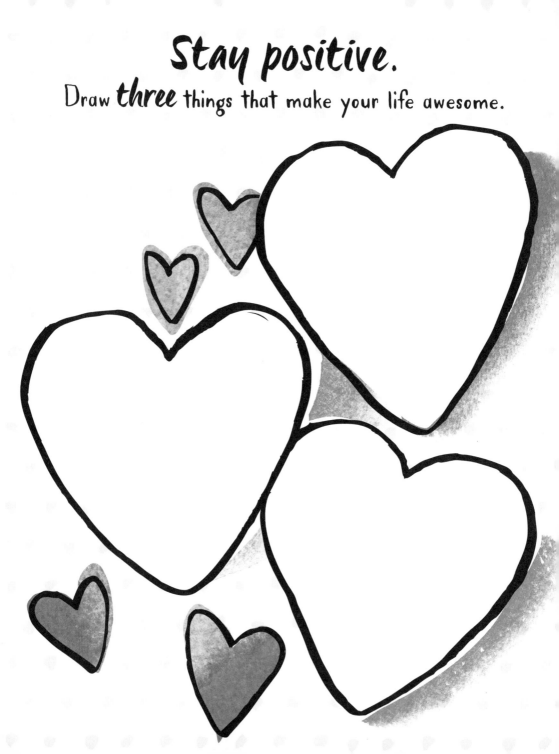

Constantly trying not to drop the ball?
Draw urgent and daunting tasks onto this ball.

Then tear out the page, scrunch it up, and throw it high into the air. Don't worry about trying to catch it!

Explore a new point of view.

Lie on your side and draw what you see.

Try to unwind.

Take this thread, continue it into a single-line drawing—
remember not to break the line of the thread—let it flow.

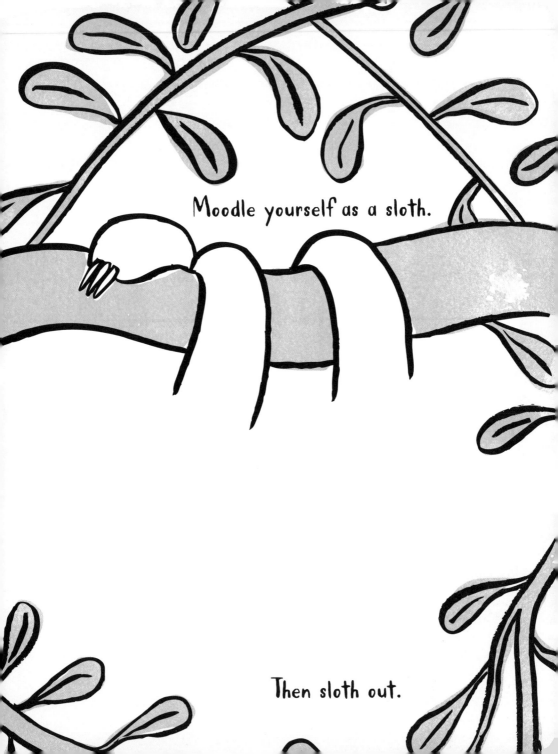

Music is great for relieving stress.
Moodle your favorite song.

Nail-biting event coming up?

Instead of ruining your nails, just rip a little bit off these nails instead, thereby saving your own precious fingers.

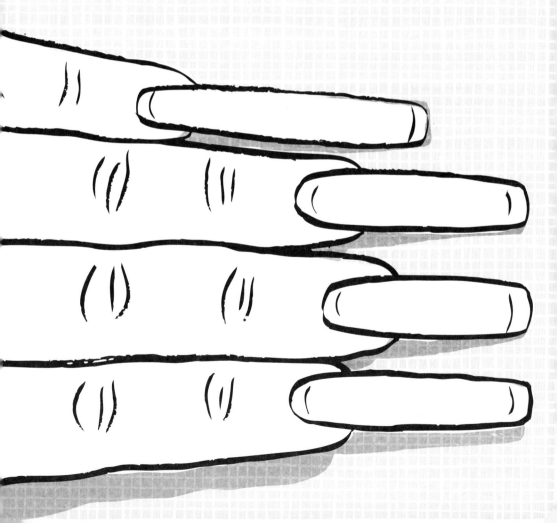

Creating harmony is a *great* way to overcome stress.

Moodle with a friend on this page.
Take turns adding one line at a
time and create something beautiful.

These nerves are on the edge.

Moodle them toward
the middle of the page.

Simplify your life.

Draw the same moodle six times,
using one less line each time.

Moodle with nature...

...by a tree.

...by running water

...in the rain.

...while sitting on grass.

Give yourself a mind-in-neutral task—

continue this pattern.

Draw a hand, then pat
yourself on the back with it.

There,
there.

Moodle yourself on this tightrope.

If you're worried about falling,
moodle yourself a safety net.

Prioritize what's in front of you over what is behind you.

Draw what you can see in
front of you in the big square and
what's behind you in the small square.

Soak up some rays on a sunny beach.

Moodle yourself a sand castle.

Hang out your laundry *for all* to see...

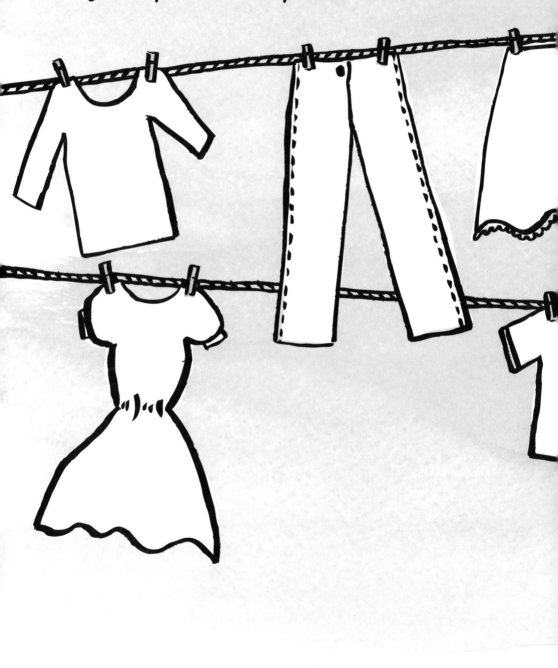

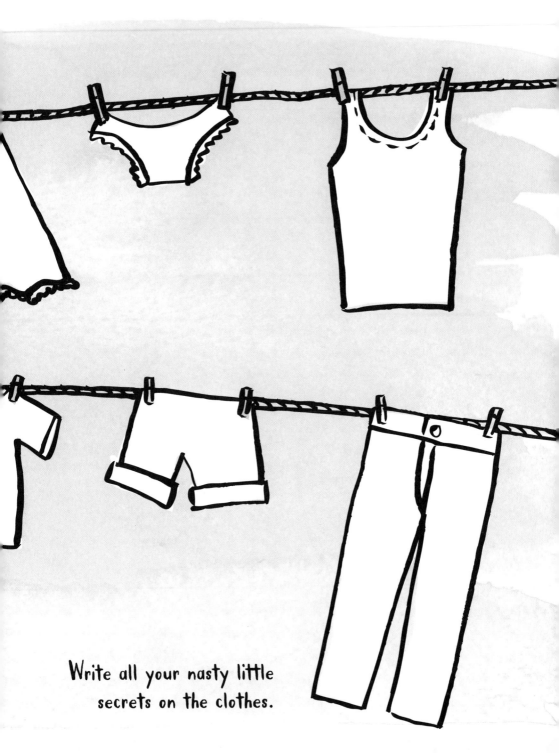

Write all your nasty little
secrets on the clothes.

Coloring can be very therapeutic.
Take your time.

It's important to give yourself positive feedback. Write a glowing review of your completed moodle book here.

All moodles complete and wisdom absorbed, you will by now be completely destressed and all tension will have been relieved. Perhaps you are even floating on a higher mental plane, unable to recall what had stressed you out in the first place. You may feel light-headed, you may feel faraway; take your time coming back to reality. Sip some water and bask in your calm and euphoric state.